THIS IS YOUR
BRAVERY TEST

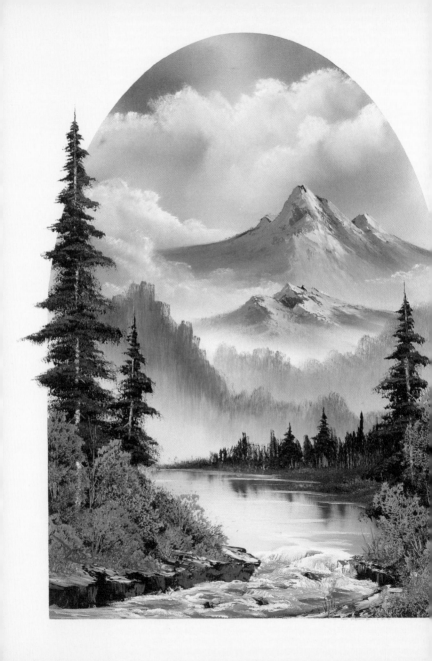

THIS IS YOUR
BRAVERY TEST

55 CHALLENGES
FOR ART & LIFE

INSPIRED BY

Michelle Witte

RUNNING PRESS
PHILADELPHIA

Hachette Book Group supports the right to free expression and
the value of copyright. The purpose of copyright is to encourage
writers and artists to produce the creative works that enrich our culture.

The scanning, uploading, and distribution of this book without
permission is a theft of the author's intellectual property. If you would like
permission to use material from the book (other than for review purposes),
please contact permissions@hbgusa.com. Thank you for your
support of the author's rights.

Running Press
Hachette Book Group
1290 Avenue of the Americas, New York, NY 10104
www.runningpress.com
@Running_Press

Printed in China

First Edition: July 2023

Published by Running Press, an imprint of Perseus Books, LLC,
a subsidiary of Hachette Book Group, Inc. The Running Press name
and logo are trademarks of the Hachette Book Group.

Running Press books may be purchased in bulk for business,
educational, or promotional use. For more information, please contact
your local bookseller or the Hachette Book Group Special
Markets Department at Special.Markets@hbgusa.com.

The Hachette Speakers Bureau provides a wide range of authors for
speaking events. To find out more, go to www.hachettespeakersbureau.com
or email HachetteSpeakers@hbgusa.com.

The publisher is not responsible for websites (or their content)
that are not owned by the publisher.

Print book cover and interior design by Amanda Richmond.

ISBNs: 978-0-7624-8303-7 (hardcover),
978-0-7624-8304-4 (ebook)

RRD-S

10 9 8 7 6 5 4 3 2 1

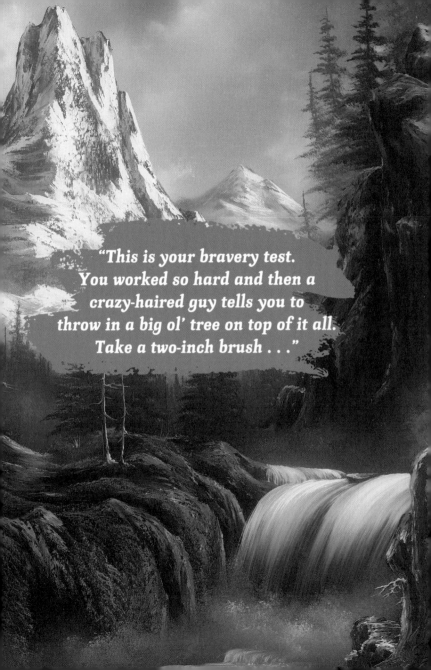

"This is your bravery test. You worked so hard and then a crazy-haired guy tells you to throw in a big ol' tree on top of it all. Take a two-inch brush . . ."

INTRODUCTION

Bob Ross was never one to shy away from a challenge. He broke the rules of the art world in his day, taking an elite endeavor that required extensive time and money to pursue, and turning it into something that anyone could do at home with basic supplies and no elaborate training. He upset many an art critic because of that, but more importantly, whether you watched him as a budding artist or an armchair enthusiast mesmerized by his style, Bob brought joy and purpose to all who tuned in each week.

In nearly every episode of his show *The Joy of Painting* he presented a challenge to his viewers:

"This is your bravery test.
Pull out your two-inch brush . . ."

And then he would proceed to slash a bold black line down the center of all the work he'd just done. A person unfamiliar with his work might gasp in horror at how he'd ruined something so beautiful, but anyone who

knew Bob recognized that this was simply the jumping-off point to something even more spectacular. From that thick line would emerge a big old tree, and, more often than not, a tree *friend*.

With every test of bravery, he offered his audience a challenge and a choice: Play it safe and keep the lovely scene you've already created, or be bold and take a risk with the promise of even greater rewards.

"After you've worked so hard to put these things in, you get up here and some fuzzy-haired crazy guy tells you to drop a big old tree in. I know that's scary. In your world, if you don't want to put this tree in, you don't put it in. But if you want to, it's a lot of fun."

This book offers you fifty-five bravery tests inspired by Bob's words to help you gather the courage to tackle life's many challenges. He would want you to be brave and push yourself to be even greater than you already are, but to also remember that, in both life and art, there are no mistakes, just happy accidents. So grab your two-inch brush, drum up your courage, and get ready to challenge the world around you.

Bravery Test N° 1

"Painting is an individual thing. Everybody sees nature through different eyes, and the way you see it is the way you should paint it."

PULL OUT THE TWO-INCH BRUSH AND GIRD your loins for a true test of your bravery as an artist: Paint an object or scene using that brush. Just that one. Don't worry about doing it "right" and simply express what nature looks—and, more importantly, *feels*—like to you. Realism isn't the object here. Stripping away the demand for perfection will allow you to focus on what nature is to you, and allow you to express it in a way you never have before.

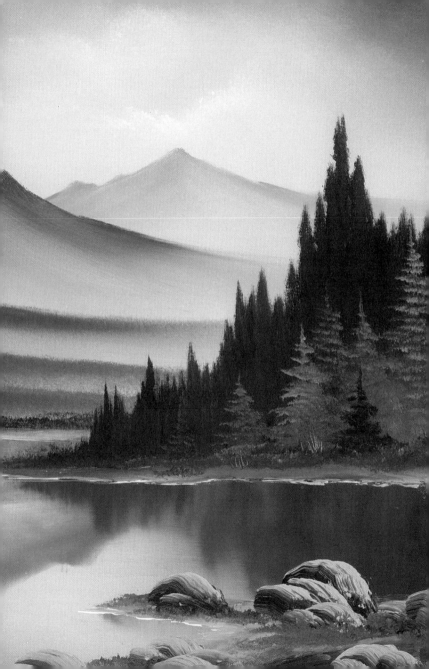

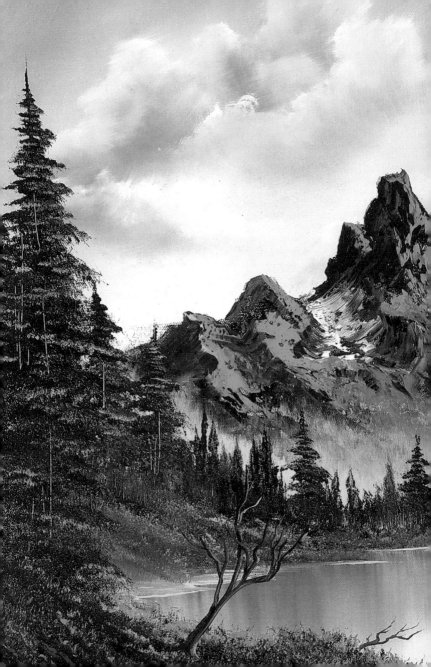

Bravery Test N° 2

"It's my escape from reality. I can go in here and I can literally create any kind of world that I want. There's tranquility and peace in my world."

CREATE TRANQUILITY IN YOUR LIFE. SET aside a corner of a room in your home as a tranquil place, or a few minutes in your day to be your tranquil time. Put a reading chair in your bedroom that is just for you, or set aside the half hour after the kids have gone to bed to sit and enjoy a cup of tea after a hectic day. Make a ritual of tranquility that you guard fiercely and that others know is a special time for you to gather your energy for the rest of the day, or as a peaceful way to end it.

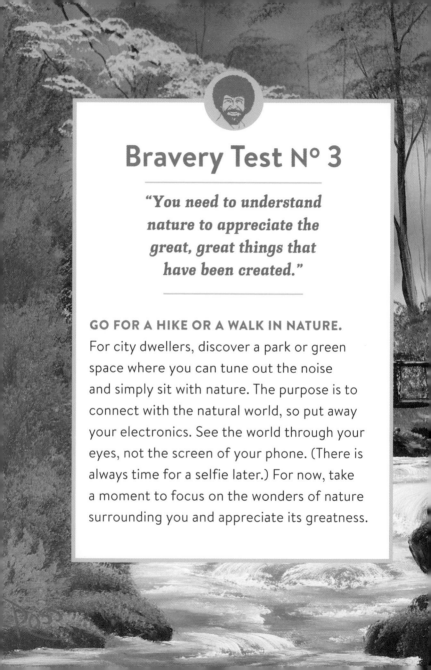

Bravery Test Nº 3

"You need to understand nature to appreciate the great, great things that have been created."

GO FOR A HIKE OR A WALK IN NATURE. For city dwellers, discover a park or green space where you can tune out the noise and simply sit with nature. The purpose is to connect with the natural world, so put away your electronics. See the world through your eyes, not the screen of your phone. (There is always time for a selfie later.) For now, take a moment to focus on the wonders of nature surrounding you and appreciate its greatness.

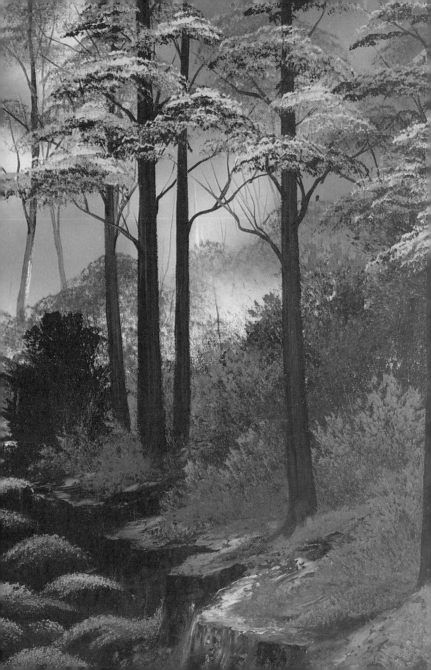

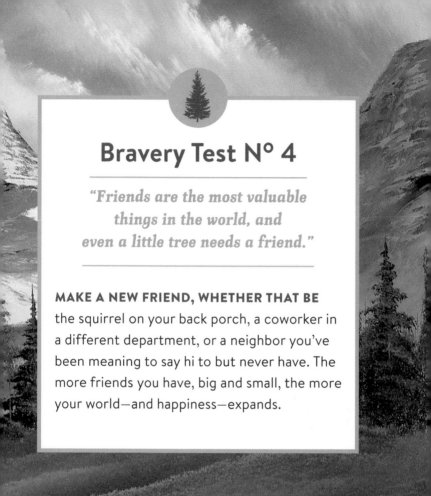

Bravery Test N° 4

*"Friends are the most valuable
things in the world, and
even a little tree needs a friend."*

MAKE A NEW FRIEND, WHETHER THAT BE
the squirrel on your back porch, a coworker in
a different department, or a neighbor you've
been meaning to say hi to but never have. The
more friends you have, big and small, the more
your world—and happiness—expands.

Bravery Test N° 5

"All we're doing is just applying a dark color, so when we put a lighter color on there, it'll show. You have to have dark in order to show light."

GO STARGAZING. NOTHING ILLUSTRATES the stark contrasts of light and dark as much as a starry sky on a clear night. If you can, climb a hill or go somewhere without a lot of light pollution, turn off any lights around you, and simply stare at the sky. Closer to home, visit a planetarium to learn about the constellations, or use a telescope to gaze at the vastness of the stars above.

Ross

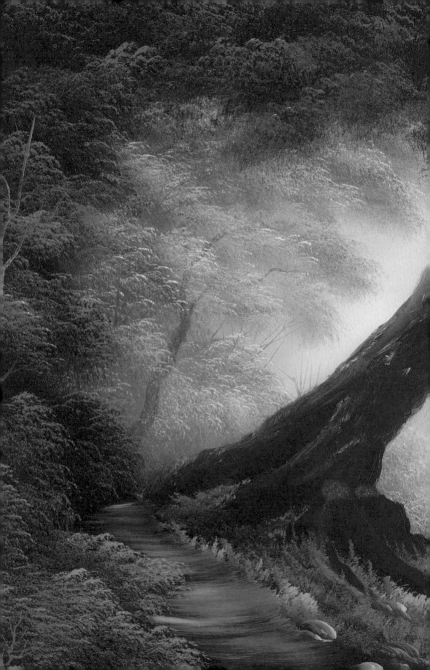

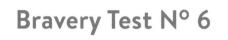

Bravery Test N° 6

"If you never had any sadness in your life, then you wouldn't know the happy times when they came. That's the reason God gives us those little sad times. That way we know when we've got a good one."

LET YOURSELF FEEL. THE WORLD TRIES to tell us that showing emotion is a sign of weakness. Instead, let yourself feel the vast range of emotions so you can appreciate the bitter and the sweet. Allow yourself to feel sadness, but then, once that is done, seek out the opposite emotion so you can experience happiness and joy as well.

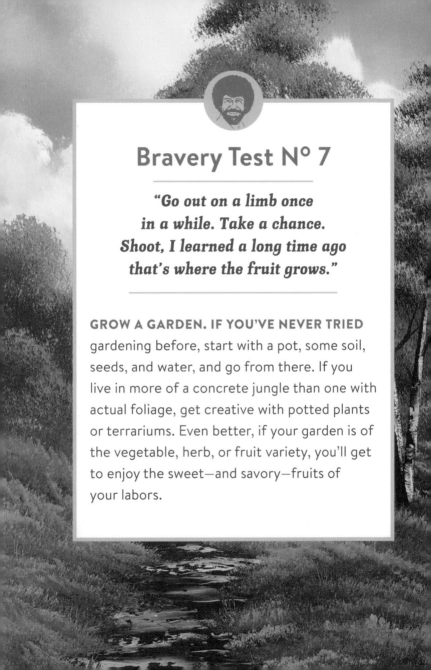

Bravery Test N° 7

*"Go out on a limb once
in a while. Take a chance.
Shoot, I learned a long time ago
that's where the fruit grows."*

GROW A GARDEN. IF YOU'VE NEVER TRIED gardening before, start with a pot, some soil, seeds, and water, and go from there. If you live in more of a concrete jungle than one with actual foliage, get creative with potted plants or terrariums. Even better, if your garden is of the vegetable, herb, or fruit variety, you'll get to enjoy the sweet—and savory—fruits of your labors.

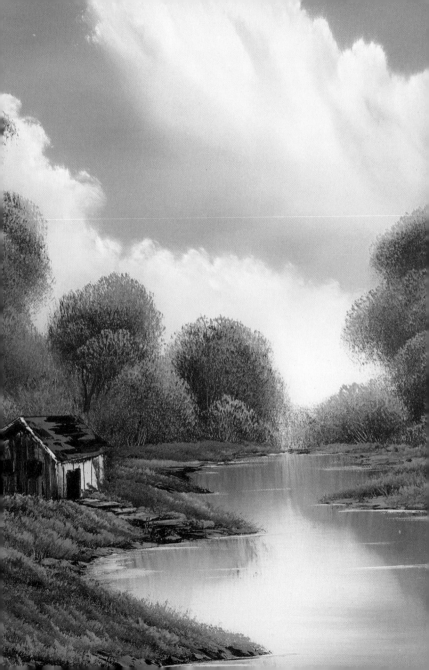

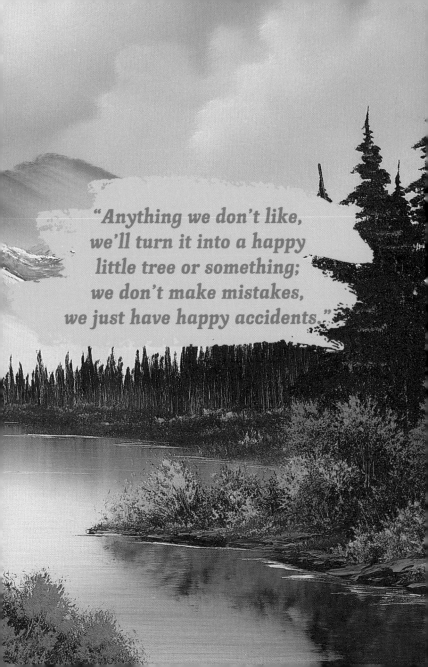

"Anything we don't like,
we'll turn it into a happy
little tree or something;
we don't make mistakes,
we just have happy accidents."

Bravery Test Nº 8

*"There are no mistakes.
You can fix
everything that happens."*

FIX YOUR MISTAKES. WHAT DO YOU CONSIDER
your biggest failure? Be completely honest
with yourself. Now reframe it—it's not a
mistake because there is still time to fix it.
Write down five things you can do to correct
the mistake. Whether it's something you did
or didn't do, you can take steps to make it
right. But remember, fixing something doesn't
mean it will be the same as it was before.
Sometimes it will end up being something
totally different, and that's okay.

Bravery Test N° 9

"They say things look better if you have odd numbers. Sometimes I'll put even numbers just to upset the critics."

DEFY THE CRITICS. YOUR INTERESTS AND tastes are all your own, so don't let anyone shame you into thinking that something you enjoy is bad. You don't have guilty pleasures; they are simply things that you like, even if others don't. Instead of hiding or excusing away something you enjoy, ignore any critics and just love what you love. You might even discover some great friends who share your interests once you're willing to openly embrace them.

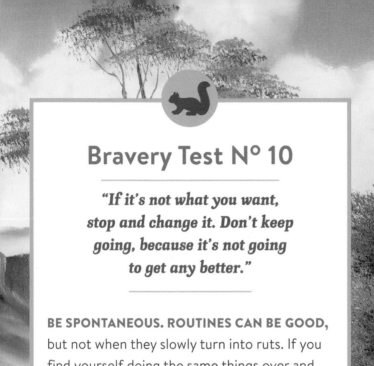

Bravery Test Nº 10

"If it's not what you want, stop and change it. Don't keep going, because it's not going to get any better."

BE SPONTANEOUS. ROUTINES CAN BE GOOD, but not when they slowly turn into ruts. If you find yourself doing the same things over and over again without any excitement, it's time to find a path out of the rut. Sometimes even just tossing an unexpected element into the routine—taking a different route to work today or trying out a new restaurant across town— can help you break out of the monotony.

Bravery Test Nº 11

"The secret to doing anything is believing that you can do it."

CATALOG YOUR DOUBTS. WHAT HAS STOPPED you from doing something you truly want to do in life? Perhaps it was your own self-doubts, or a person who in the past created that doubt in you. Don't listen to that voice any longer. Shut it out, and then tell that voice why it can't stop you from accomplishing your goals anymore. Shout it from the rooftops. No one can stop you from believing in yourself.

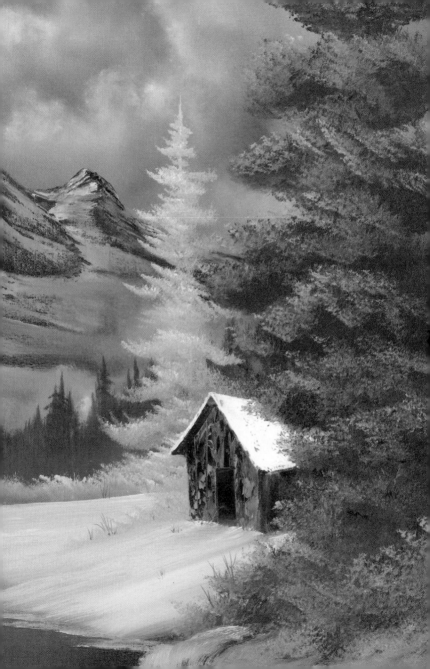

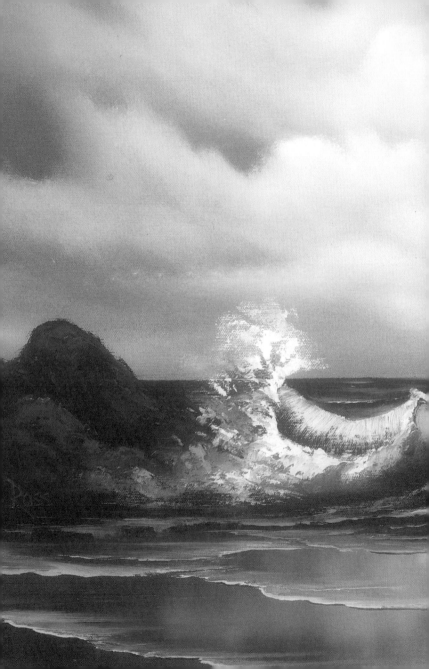

Bravery Test N° 12

"Don't forget to tell these special people in your life just how special they are to you."

WRITE A LETTER TELLING SOMEONE JUST how much they mean to you. Or if you're feeling really brave, tell them in person. Revealing your true feelings can be scary, but don't worry about how it'll be received. Simply tell your loved one how special they are as part of your life, because they might not know. You might not realize how much they mean to you either—not until you express it.

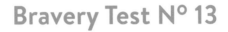

Bravery Test N° 13

"Sometimes when we're painting, the hardest thing is to make a decision what to do. Just haul off and do something. To do nothing is worse."

DO SOMETHING YOU'VE BEEN PUTTING off. Indecision and fear of failure can be paralyzing. Choose one thing you've been wanting to do or learn for ages, and then set a date when you will start. No more excuses, no worries that you won't do it right. Circle that date on the calendar and, when it arrives, put paintbrush to canvas or stride into that classroom no matter what. You'll never finish the race if you can't get past the starting gate.

ROSS

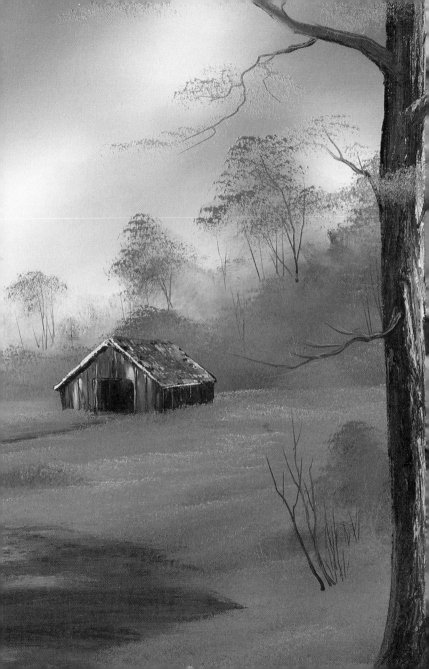

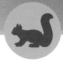

Bravery Test N° 14

"You want the paint to break. That's what makes all those beautiful little things that you see in there."

CREATE A MOSAIC. TAKE SOMETHING BROKEN and use the pieces to create something else even more spectacular. Instead of lamenting the loss of your favorite dish, which broke into pieces on the kitchen floor, gather those pieces and put them back together in a new pattern with a bit of glue and some grout to create a gorgeous flowerpot or coaster. (But be sure to use sturdy gloves or other protective gear when handling the pieces.) Just because something is broken doesn't mean it's ruined. It can be transformed into something else with an entirely different kind of beauty and be just as special, if not more so.

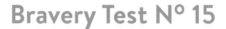

Bravery Test N° 15

"You can have anything you want—but you have to help enough other people get what they want."

FIND OUT A SECRET WISH OF SOMEONE in your life and then help them achieve it. It might be something as simple as learning to paint or as big as a trip to the city of their dreams. Whatever it is, encourage them in their long-held desires. They might be reluctant at first, especially if it's a wish they've had for a long time, but sometimes all a person needs is someone else to take that first big scary step with them.

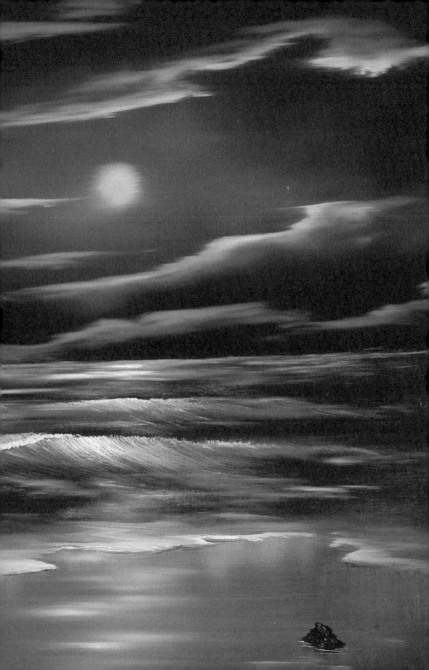

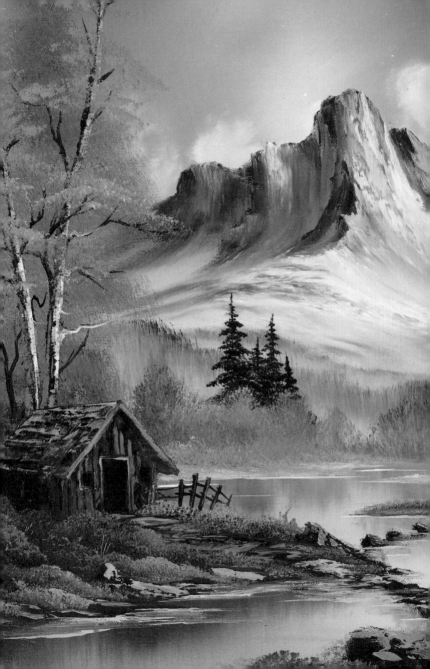

Bravery Test N° 16

"We don't know where this goes, and I don't know that we care."

GO ON A JOURNEY WITHOUT A DESTINATION in mind. Pack your bag with some food and water, then pick a direction and go. It could be a road trip in your car or a train ride going anywhere. Keep your phone handy in case you get a bit too far off the beaten path and aren't quite sure how to get back, but appreciate every moment of the journey, even if the path never actually reaches a destination.

"The object is to
capture the dream quickly,
while it is still alive."

Bravery Test N° 17

"If we're going to have animals around, we all have to be concerned about them."

CARING FOR ANIMALS MEANS MORE THAN adopting a pet. There are many ways to support all living creatures, both in your community and around the world. Grow wildflowers or other vegetation specifically for the birds, bees, or other wildlife in your area. Don't use pesticides or herbicides in your garden that are harmful to the local fauna. Get involved in conservation efforts. If you would like to care for a creature, consider taking in a pet who is a bit older or otherwise unwanted. Caring for them will bring endless joy to your life.

Bravery Test Nº 18

"Painting to me represents freedom. I can create the kind of world that I want to see and that I want to be part of."

CREATE A HAPPY AND JOYFUL WORLD FOR yourself. To make sure that your world stays a happy one, set healthy boundaries and be firm in enforcing them. Within the circle of what you can control, build a world that brings you joy. Maybe in your world there are no demeaning words or insults. Anyone who wants to spend time in your world can and should respect that. You get to set the rules for your world because it is *yours*.

Bravery Test Nº 19

"Trees don't grow perfect. They're like us; they have flaws and imperfections."

EMBRACE YOUR IMPERFECTIONS. NO human on this planet is perfect, no matter what social media and photo filters want you to believe. Rather, look for the little flaws and imperfections that make you stand out. That annoying mole on your cheek can become a beauty mark instead if you stop hiding it and accept it as part of what makes you special.

Bravery Test N° 20

"You do your best work if you do a job that makes you happy."

DOES YOUR JOB MAKE YOU HAPPY? TAKE some time to evaluate how you spend your day, whether in a full-time career, doing part-time work, as a student, or as a stay-at-home parent. If you're not happy, what things can you change that would make your work more fulfilling? For some, the answer might be to change your job or your career, but for most, it will be less extreme. Build up the courage to ask for that promotion, open a dialogue with your boss and coworkers to improve morale, let your partner know that you need more support at home. There are often small changes that can be made that will improve the situation for everyone.

Bravery Test N° 21

"It's hard to see when you're up very close. Step back and look at it, and you'll see a whole new perspective."

CHANGE YOUR PERSPECTIVE—LITERALLY. Climb a tree or a mountain, or even take an elevator to the top of a tower and then consider how different the world looks from that standpoint. A slight change in elevation can alter your perception of the world around you and let you see it through new eyes.

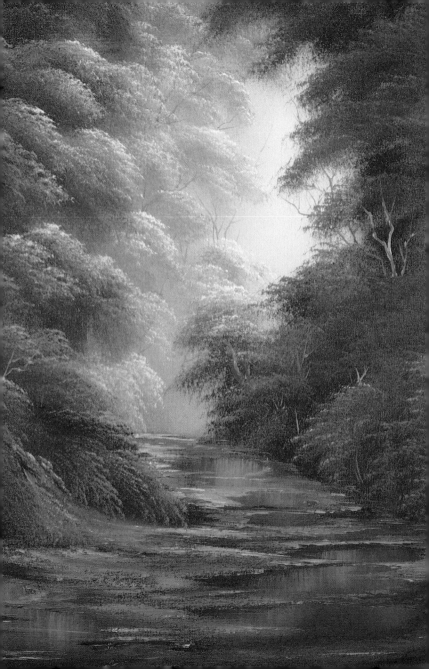

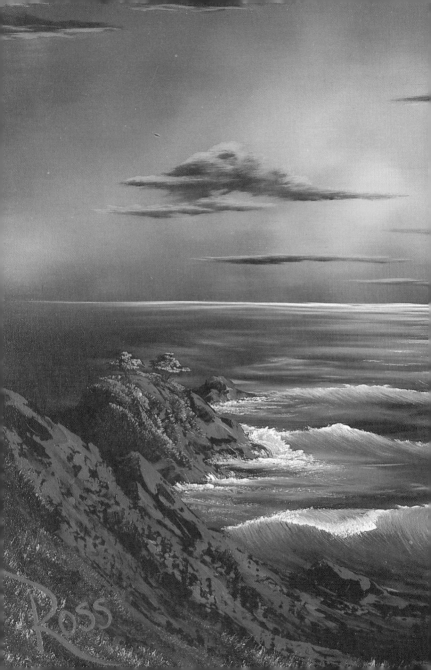

Bravery Test N° 22

"When you buy your first tube of paint, you're issued an artist's license. An artist's license says you can do anything you want to do."

GIVE YOURSELF LICENSE TO BE AN ARTIST.
No formal training or exams are required for this type of license. An artist's license means that you can do anything you want with your art, and no one can tell you any different. This is your art and your world. Think of one thing you've always wanted to try as an artist and then do it, no matter how wild it sounds.

Bravery Test N° 23

"Take your time.
Speed will come automatically."

TAKE A SLOW DAY. FOR THOSE WHO ARE glued to their technological gadgets—literally or figuratively—shut them all off for a day. Let friends and family know that you'll be unreachable, and then power down all your devices. Every single one. Though it might feel like cutting off a limb at first not to have your phone constantly chirping at you, a day without electronic distraction will force you to slow down and appreciate life.

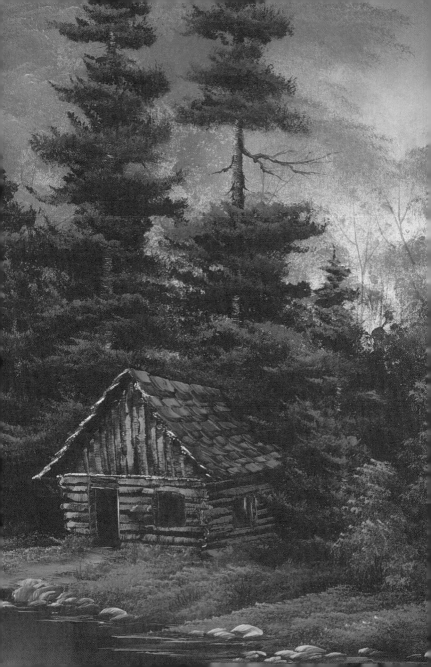

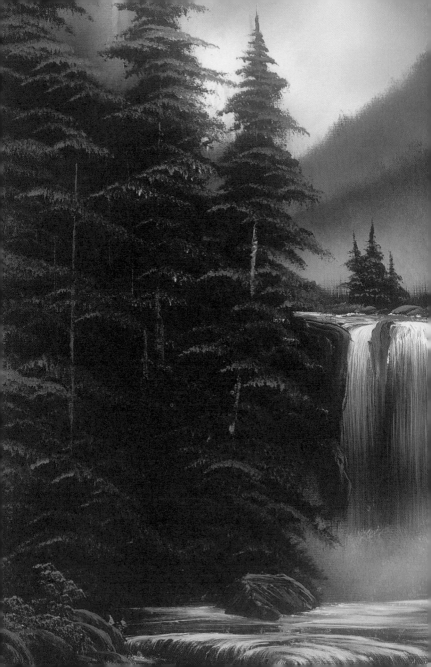

Bravery Test N° 24

"That's when you truly experience the joy of painting— when there's no fear."

FACE YOUR FEARS. EVERYONE HAS SOME-thing they fear in life, whether it's something tangible, like drowning or clowns, or intangible, like loneliness or failure. With the help of a friend (or a professional, if needed), stand up to a fear that you've avoided dealing with in the past. You may not conquer it completely, but you'll know that you have the strength to face it.

Bravery Test N° 25

"Trees grow in all kinds of ways. They're not all perfectly straight. Every limb's not straight."

MANAGE YOUR HEALTH. HUMAN BODIES are like trees in growing how they will despite our best efforts, never perfect or symmetrical, and for some people, never completely healthy. Even though you can't control how your body will grow or certain health issues that might arise in the future, focus on the things that you do have control over, like what you put into your body and the care you give it. Understanding your health can have a substantial impact on your life, especially when you're able to recognize that something isn't working the way it has been or it should. Then you can seek help.

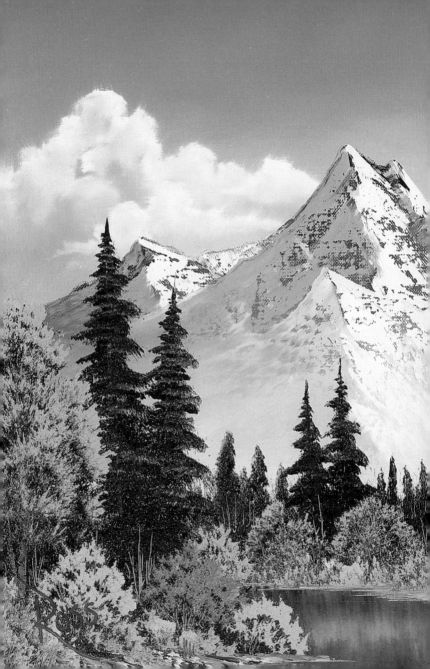

Bravery Test N° 26

"Talent is a pursued interest. Anything that you're willing to practice, you can do."

DON'T JUST IMAGINE WHAT IT WOULD BE like to paint alongside Bob, *actually do it*. Many of Bob's most devoted fans have never picked up a paintbrush while they watch the show. Instead of watching him paint a magnificent landscape, get some basic materials from the art or craft store and join him. More than anything, he wanted people to love painting as much as he did so they could experience the joy it brings.

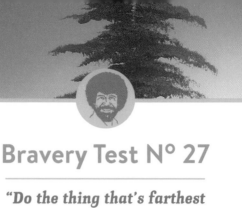

Bravery Test N° 27

"Do the thing that's farthest away first. Then work forward, always working forward."

CHOOSE THE TOP ITEM ON YOUR BUCKET list, and then figure out how you're going to make it happen. Instead of putting it off as something that you'll do eventually, set some long-term goals that will turn a dream into a reality. If it's too expensive for you right now, start a savings account specifically for that purpose. Even a few dollars a paycheck will add up over time.

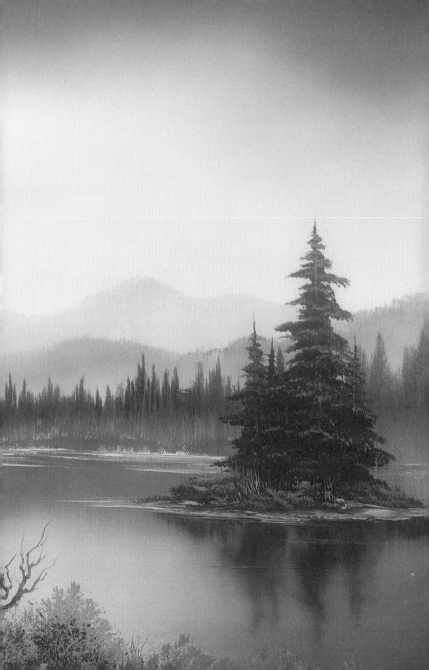

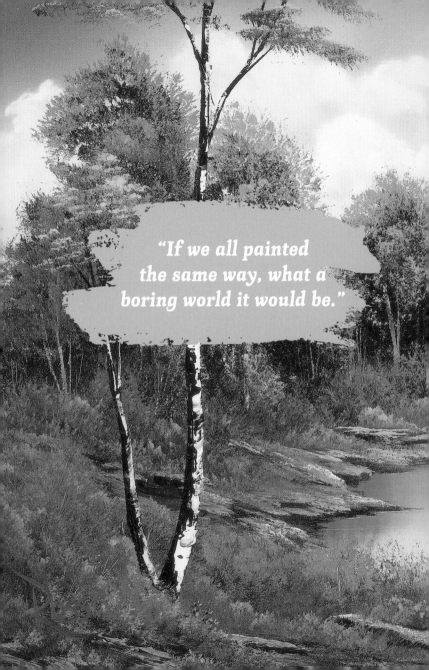

"If we all painted
the same way, what a
boring world it would be."

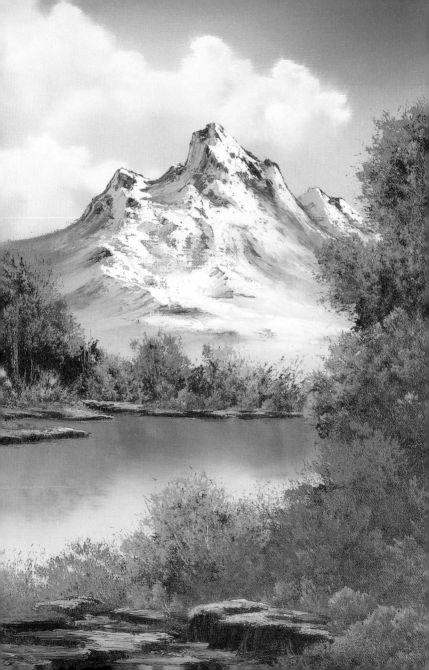

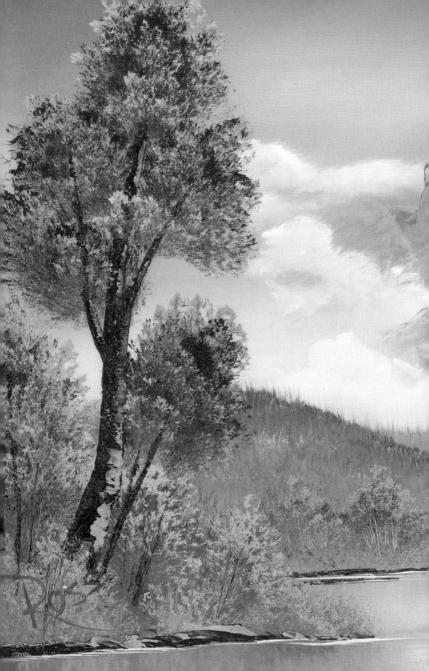

Bravery Test N° 28

"You can't make a mistake with this. Anything that happens, you can learn to use it and make something out of it."

UNPACK YOUR GUILT. LIFE IS FILLED WITH missteps and miscalculations, but they needn't control you. As Bob would always say, they aren't mistakes because you can fix them. Think back to an error you made in the past and then unburden yourself of the guilt. If it's something that caused harm to another, apologize and make amends. If you've never said it aloud, admit your error and then let it go. Free yourself of the weight that guilt has caused so that you're able to learn and then make something beautiful out of the experience.

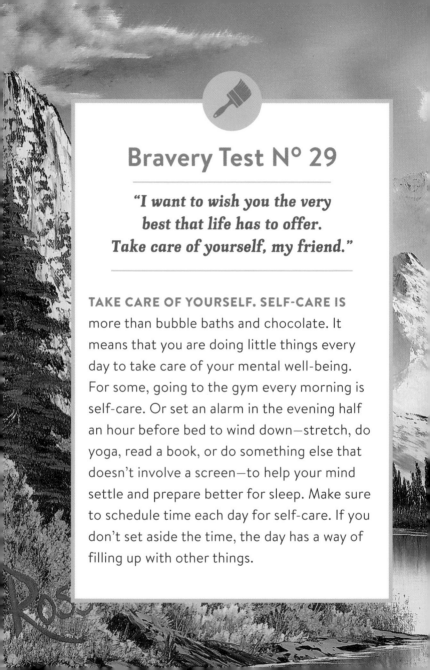

Bravery Test N° 29

"I want to wish you the very best that life has to offer. Take care of yourself, my friend."

TAKE CARE OF YOURSELF. SELF-CARE IS more than bubble baths and chocolate. It means that you are doing little things every day to take care of your mental well-being. For some, going to the gym every morning is self-care. Or set an alarm in the evening half an hour before bed to wind down—stretch, do yoga, read a book, or do something else that doesn't involve a screen—to help your mind settle and prepare better for sleep. Make sure to schedule time each day for self-care. If you don't set aside the time, the day has a way of filling up with other things.

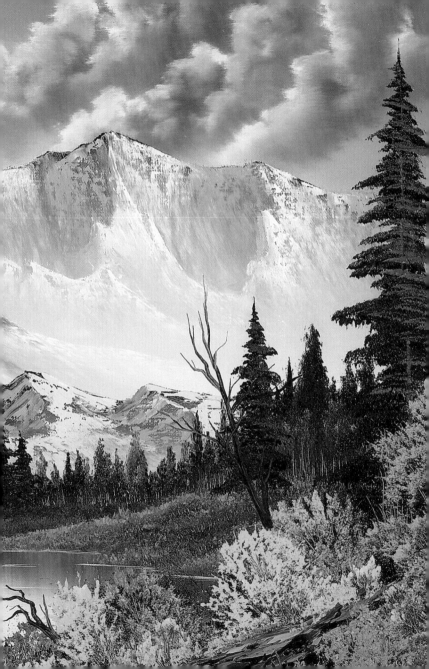

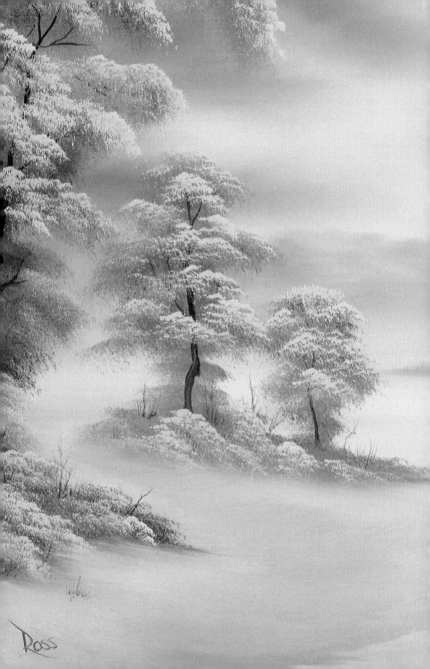

Bravery Test Nº 30

*"Any time you learn,
your time and energy
are not wasted."*

LEARN SOMETHING YOU'VE ALWAYS WANTED
to learn but never took time to. Sign up for
a class, learn a language, start a new hobby.
Tutorials and videos from both experts and
amateurs are available online for free on every
topic imaginable. In this technological world,
there's nothing you can't learn if you put in
the energy to do it.

Bravery Test N° 31

"We're gonna make some big decisions in our little world."

TIME TO DECIDE. WHAT IS THE BIGGEST, scariest decision you need to make in your life right now? If you've been procrastinating making a choice, it's time to stop putting it off. Do some research, and make a plan. Break it down into bite-sized chunks so the challenge doesn't seem quite so gargantuan and is more manageable. Then it isn't one big decision, but a number of little ones that will lead you to the same result, but with less stress.

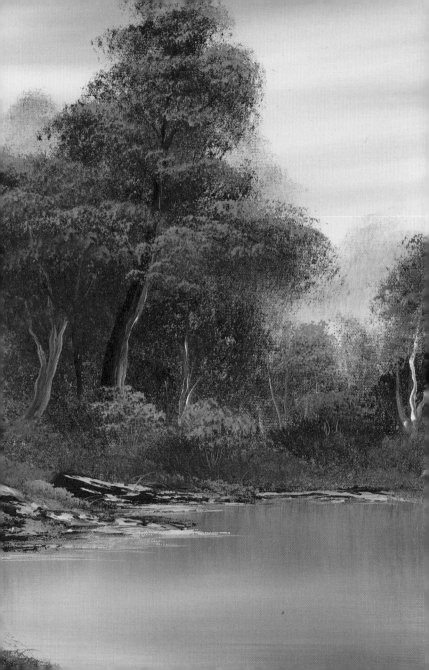

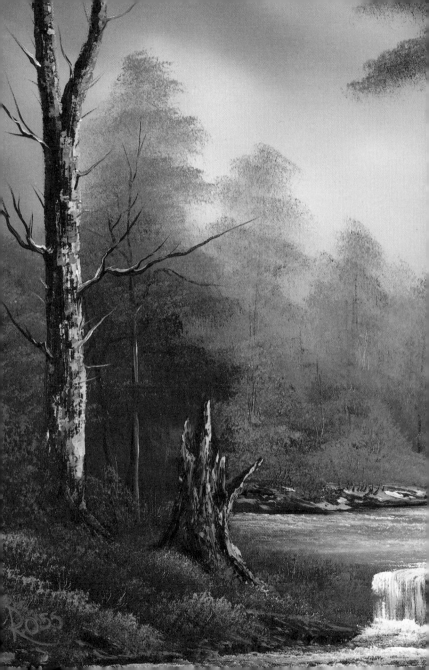

Bravery Test Nº 32

"Sometimes you learn more from making mistakes than you learn from trying to paint a beautiful masterpiece."

CREATE A MASTERPIECE FROM MISTAKES.
Found art plays with the idea of taking what has been discarded or thrown away to create art. If you're not sure where to start, find one item, like a discarded concert ticket or a flyer that strikes your fancy, and build from there. Use your imagination to turn that mistake into a work of art completely unrecognizable from what it started as.

Bravery Test N° 33

"Believe in yourself.
Believe in what you can do."

YOU CAN DO IT. FIND A SPOT WHERE YOU can be as loud as possible and prepare your vocal cords for a bit of yelling. If you're self-conscious, you can do this in the car while you're driving down a busy road so no one will hear you. The test? Let the world—and, more importantly, you—know that you believe in yourself. Just thinking it isn't enough; you need to say it out loud. Choose a phrase that means something to you, perhaps to counter a self-doubt that has plagued you in the past. "I can do this! I believe in myself!" Shout it as many times as necessary to feel that it is true.

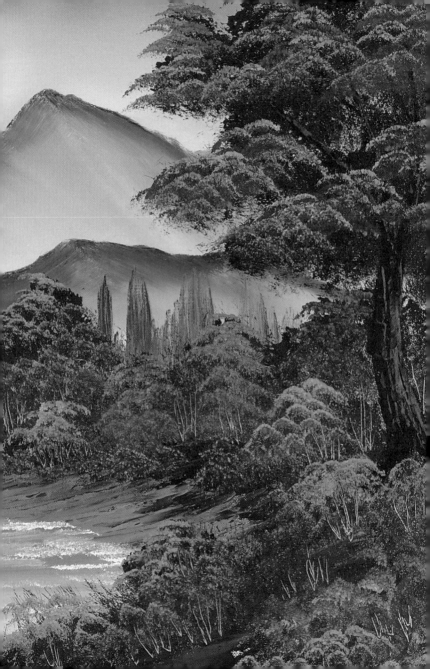

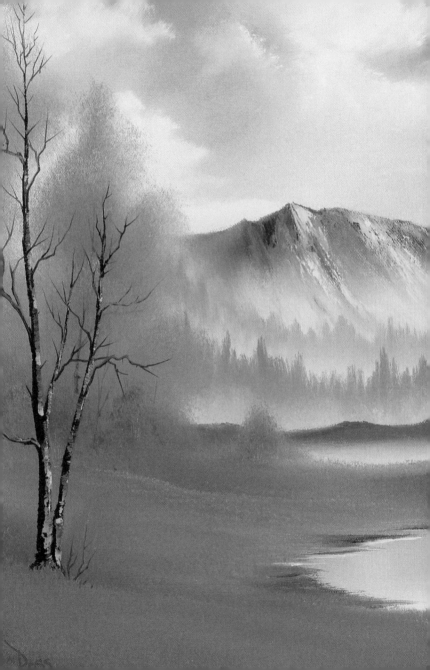

Bravery Test N° 34

*"You don't make mistakes.
If you do something wrong,
scrape it off and do it again."*

START AGAIN. PULL OUT AN OLD PROJECT, one you gave up on halfway through or because you thought it was a failure. Don't focus on what's wrong with it, but on what has potential. Then take that and run with it. Perhaps what you'd originally envisioned isn't what this project needs. Or maybe it wants to be something else altogether. Don't let one failed attempt stop you from using the core materials to create something even greater than what you originally envisioned.

Bravery Test N° 35

"I think there's a creative being that lives in each and every one of us, and in children, still free."

BE A CHILD FOR A DAY (OR AT LEAST A couple of hours). Explore the world with a childlike sense of wonder, full of questions. Don't let the adult in you inhibit the wonder by focusing on the reasons something can't or shouldn't be, or by giving boring explanations for the things around you. Maybe that rainbow really does lead somewhere magical. Chase it and find out.

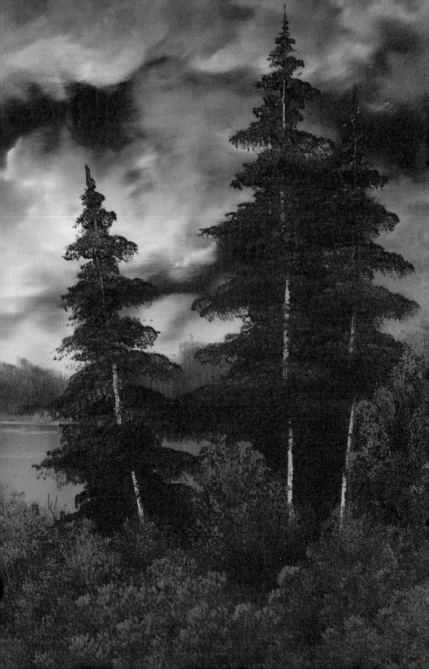

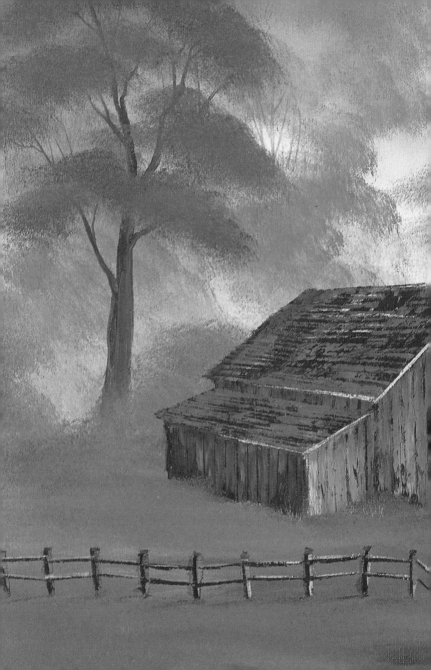

Bravery Test N° 36

"Anything that you want in your painting is right. That's just the way it should be, because we each see nature through different eyes. Your painting should reflect what you see. Not what somebody else tells you is right, but what you feel is right."

DON'T *SHOULD* YOURSELF. TELLING YOUR-self constantly that you *should* be the perfect parent or employee, or that you *shouldn't* be upset over heartbreak does nothing but pile on unnecessary—and untrue—expectations of yourself. Anytime you catch yourself forming a thought with the word *should* in it, stop and reframe it in your mind. No, you aren't perfect, but the only thing you *should* be is yourself.

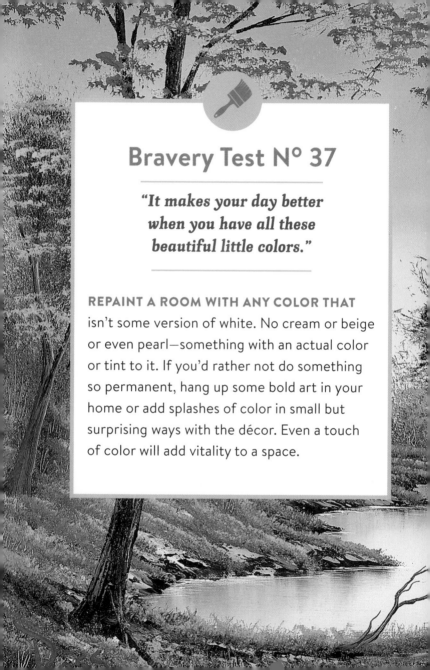

Bravery Test Nº 37

"It makes your day better when you have all these beautiful little colors."

REPAINT A ROOM WITH ANY COLOR THAT isn't some version of white. No cream or beige or even pearl—something with an actual color or tint to it. If you'd rather not do something so permanent, hang up some bold art in your home or add splashes of color in small but surprising ways with the décor. Even a touch of color will add vitality to a space.

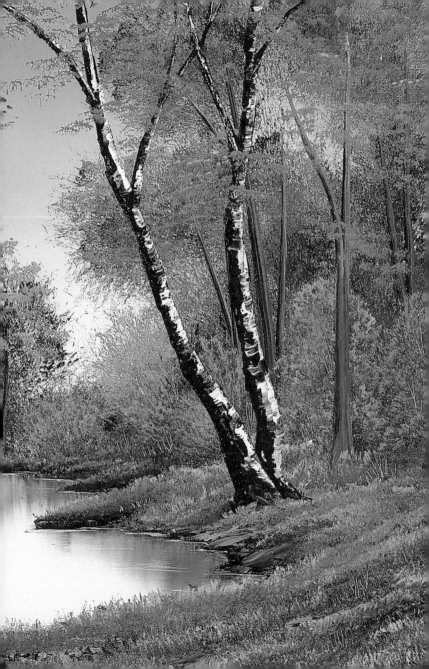

Bravery Test N° 38

"You're the greatest thing that has ever been, or ever will be. And you're special. You're very special."

TIME FOR A SELF-PORTRAIT. BUT WE'RE NOT going for realism here. Instead, paint yourself as Bob would paint you. I guarantee that he would see the miraculous gift you are to the world and paint you accordingly. Be gentle with yourself and ignore any perceived flaws. Show the goodness inside you in all your glory on canvas.

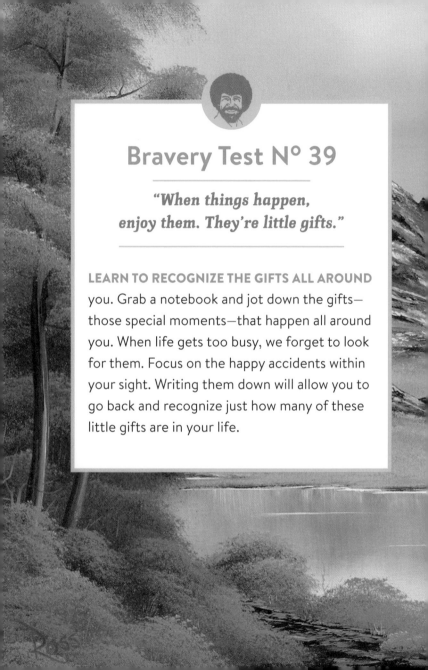

Bravery Test N° 39

"When things happen, enjoy them. They're little gifts."

LEARN TO RECOGNIZE THE GIFTS ALL AROUND you. Grab a notebook and jot down the gifts—those special moments—that happen all around you. When life gets too busy, we forget to look for them. Focus on the happy accidents within your sight. Writing them down will allow you to go back and recognize just how many of these little gifts are in your life.

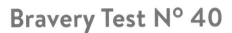

Bravery Test N° 40

*"Life is too short to
be alone, too precious.
Share it with a friend."*

RECONNECT WITH SOMEONE YOU'VE LOST
touch with over the years. Think back to a
person who meant a lot to you as a child,
or your best friend in high school—the one
you haven't heard from in ages. With social
media, it's easier to track down people from
the past than ever before. Don't go in with
any expectations. Simply let them know how
much they meant to you and that you'd like
to reconnect. They might not reciprocate, but
you can be proud that you made the effort.

"The secret to doing anything is believing that you can do it. Anything that you believe you can do strong enough, you can do. Anything."

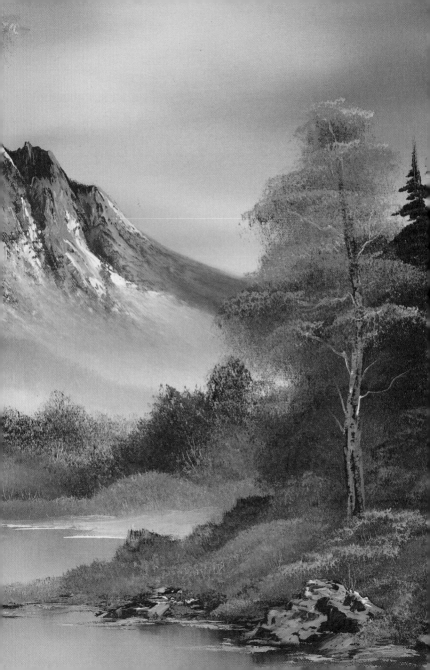

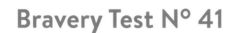

Bravery Test N° 41

"The very fact that you're aware of [suffering] is enough reason to be overjoyed that you're alive and can experience it."

ALLEVIATE SUFFERING AROUND YOU. IT doesn't need to be a big effort or require a major donation to a fundraiser. Cleaning the driveway of snow for a homebound neighbor, taking a meal to a friend who is discouraged, or offering some small kindness when you see a chance can make a world of difference for those who receive it. Every effort to reduce suffering grows exponentially, spreading happiness and joy farther than your little gift of kindness.

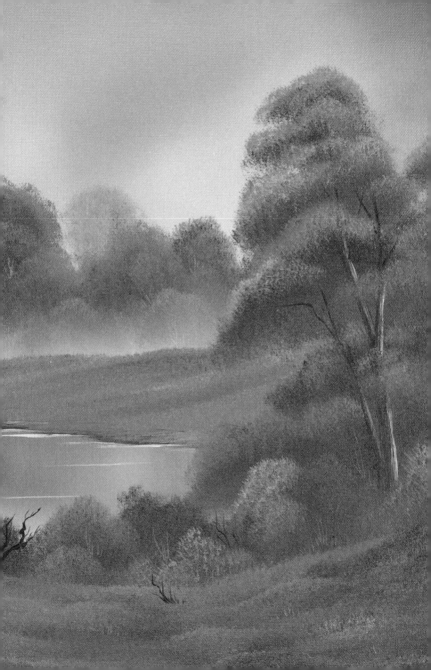

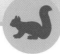

Bravery Test Nº 42

"I look for ways that are easy. In technical terms that's known as laziness."

FIGURE OUT WHAT IS TAKING TOO MUCH of your time, then stop doing it. Find a lazy solution to something you hate doing so you can spend time doing things you want. Throughout history innovations have come about because people wanted to get boring, tedious things done faster and more easily. What can you innovate in your life to make cooking, cleaning, mowing the lawn, and mending less of a chore? Sometimes the answer is as simple as paying (or bartering with) someone else to do it for you.

Bravery Test N° 43

"People expect artists to be a little different. Don't let them down!"

OWN YOUR WEIRDNESS. NORMAL IS BORING.
Why would you want to be the same as every other person on the planet? Learn to appreciate your individuality and ignore any haters. Let your weirdness shine for all to see. The world will be drawn to you like fireflies to a bug zapper.

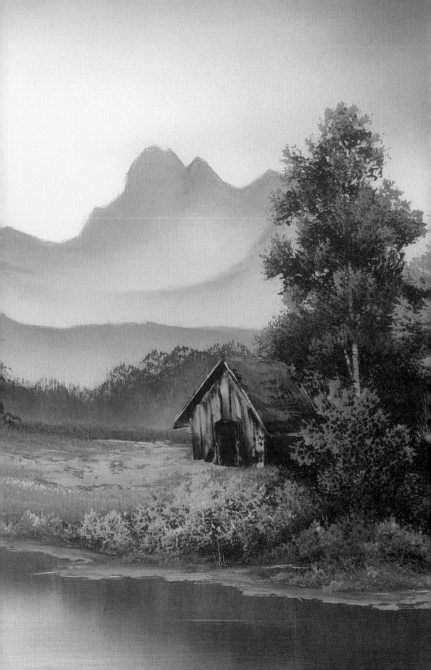

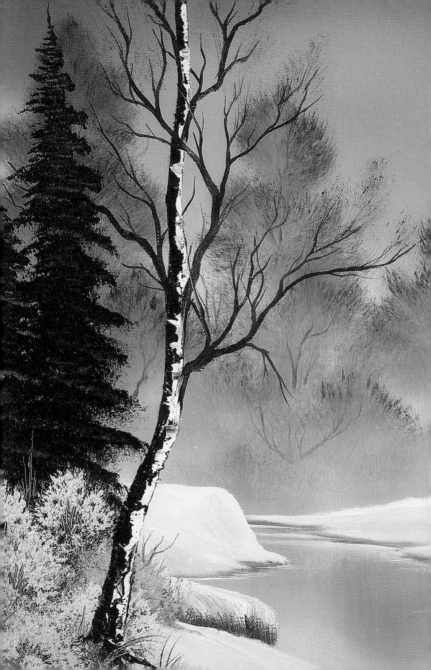

Bravery Test N° 44

"I want these trees to look like they're just sitting in a little mist, just breathing in the cold air."

LEARN HOW TO BREATHE. THERE IS NO quicker way to bring on a sense of calm and peace than by breathing deeply. The trick is to breathe into your diaphragm, letting your stomach puff out like a balloon as you inhale. Breathe in slowly through your nose until your lungs are filled with air. Pause for a heartbeat. Then slowly release the air through your mouth with your lips pursed, like breathing out through a straw. Practice this for a few minutes as you wake up in the morning and again as you prepare to sleep at night. Do this liberally throughout the day as needed. The wonder of deep breathing is that it can both soothe and invigorate.

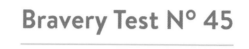

Bravery Test N° 45

"There's enough sorrow in the world. You can just watch the news if you want to see bad stuff. In this world here, everything's happy."

CHOOSE HAPPINESS. IT'S MUCH EASIER said than done, of course, but you can choose to seek happiness. The key is not to ignore negative emotions or pretend that you don't ever have them. Instead, set a timer on the pity party. Lose out on a big promotion you were sure you'd get? Buy that bucket of chicken wings and tub of ice cream, and let yourself sulk—but only until Sunday night. After that, it's time to put the negative emotions aside and focus on the good things headed your way.

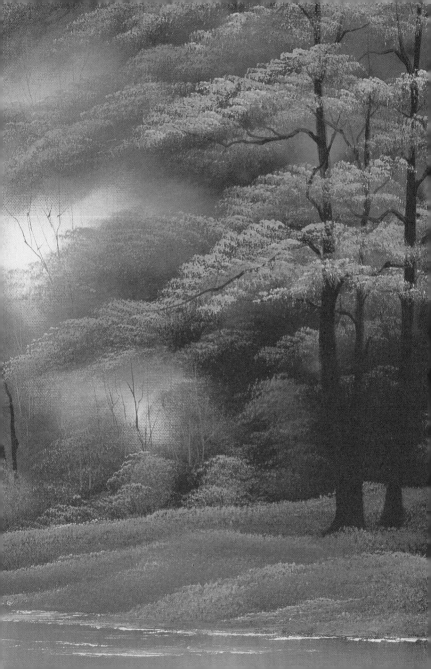

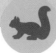

Bravery Test Nº 46

"To make something with your own hands and your own heart and give it to somebody because you care about them—that's special."

THE NEXT TIME YOU NEED A GIFT FOR a family member or friend, put the credit card away and make their present instead. It doesn't need to be a painting or even a physical object; it can be anything, as long as it took time and effort for you to create it with that person in mind. Even better, don't wait for a special occasion and simply offer a piece you created to someone you care about.

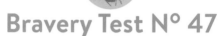

Bravery Test Nº 47

"This is your world.
Your dreams come real here."

KEEP A DREAM JOURNAL. GET IN TOUCH
with your subconscious and what it is trying to
tell you by writing down your dreams as soon
as you can after waking. Dreams slip from
your thoughts quickly once you're awake,
but making an effort to remember them can
provide insight into what your mind is focused
on, even if you don't realize it consciously.
For those who struggle to recall their dreams,
take the moments after waking to clear your
head and write down a few thoughts as you
prepare for the coming day so you can face
any concerns—conscious or subconscious—
head-on.

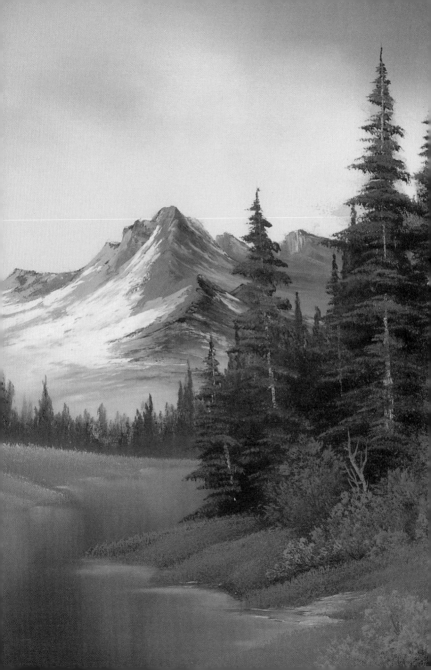

Bravery Test N° 48

"Your paintings reflect your mood. If you're in a bad mood, you'll paint an angry old painting. That's when you do the big storm clouds. And when you're happy, your paintings will reflect that. They'll be bright and cheery, and the colors will be super."

THERE ARE SOME DAYS WHEN IT FEELS LIKE a storm is hovering over you and others when nothing can stop the sun from shining. Art doesn't just happen on good days, so use your art as a tool to understand your moods. Using your preferred artistic medium, express how you feel in the moment. Is your art visceral and raw, with ragged edges and thick lines? Or is it lighter, full of color and hope? Maybe it's a bit of both. Sometimes the greatest art can come on days that are more rain cloud than rainbow.

Bravery Test N° 49

*"Just think like a tree . . .
how would you like to grow here?"*

PRACTICE MINDFULNESS. LEARN HOW TO
think like a tree by listening to the world
around you. Feel the warmth and comfort of
the sun on your skin as you sip your morning
coffee. Pay attention to each breath as it
enters and exits your body. Be present and
alive, just like a tree.

Bravery Test N° 50

"If what you're doing doesn't make you happy, you're doing the wrong thing."

FIGURE OUT WHAT IS MAKING YOU UNHAPPY.
Oftentimes the things that are truly causing us anxiety aren't easy to pinpoint, and so we need to dig a little deeper. Take out a sheet of paper (physical or virtual) and write down the things that are causing you stress right now. If you aren't sure what is triggering the anxiety, pay attention to other details: When did you start to feel that way? What were you thinking about right before that moment? Begin peeling away the layers as you would an onion, until you get to the heart of the issue. It's only after you understand what is really bothering you deep down that you can fix it.

Bravery Test N° 51

"The true joy of painting is when you share it with other people."

SHOW YOUR TALENT TO OTHERS. DON'T worry about their reactions, just share with them the joy you have in pursuing a talent or skill, whether you feel that you're good at it or are just beginning. It can take a lot of courage to let somebody in on something so personal for the first time, but wonderful things can happen when you open up your inner self to those who care about you most.

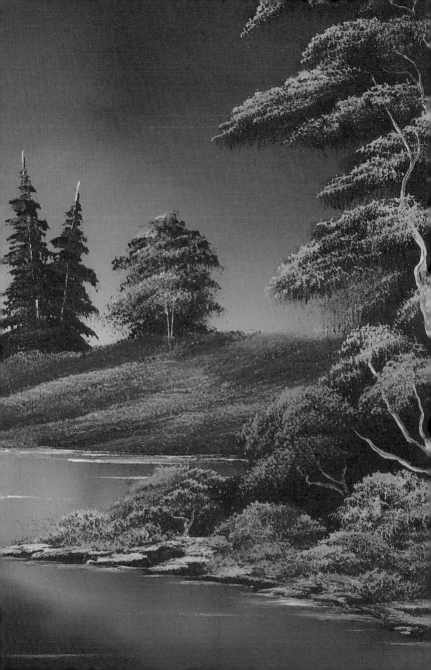

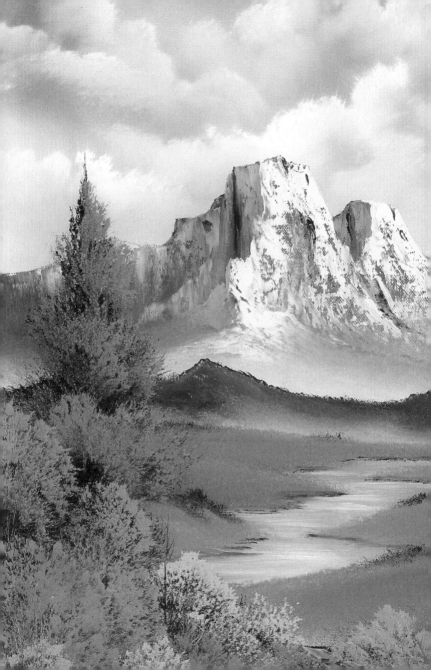

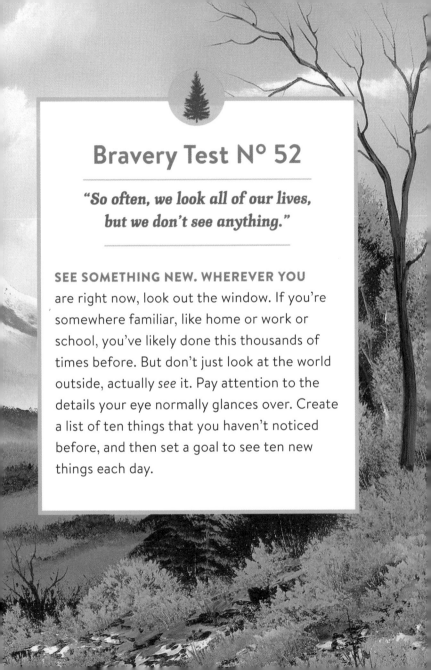

Bravery Test N° 52

"So often, we look all of our lives, but we don't see anything."

SEE SOMETHING NEW. WHEREVER YOU are right now, look out the window. If you're somewhere familiar, like home or work or school, you've likely done this thousands of times before. But don't just look at the world outside, actually *see* it. Pay attention to the details your eye normally glances over. Create a list of ten things that you haven't noticed before, and then set a goal to see ten new things each day.

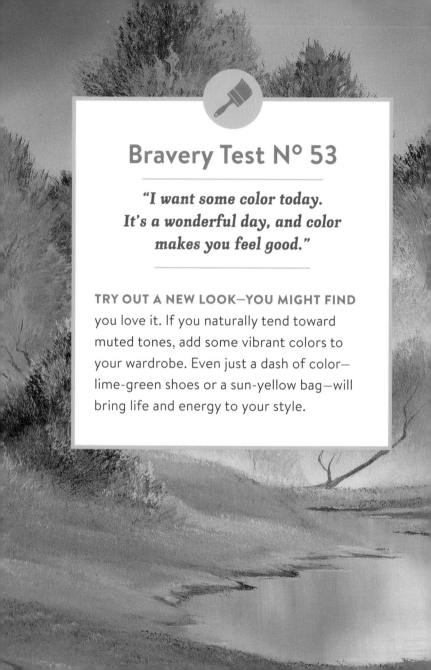

Bravery Test N° 53

*"I want some color today.
It's a wonderful day, and color
makes you feel good."*

TRY OUT A NEW LOOK—YOU MIGHT FIND you love it. If you naturally tend toward muted tones, add some vibrant colors to your wardrobe. Even just a dash of color— lime-green shoes or a sun-yellow bag—will bring life and energy to your style.

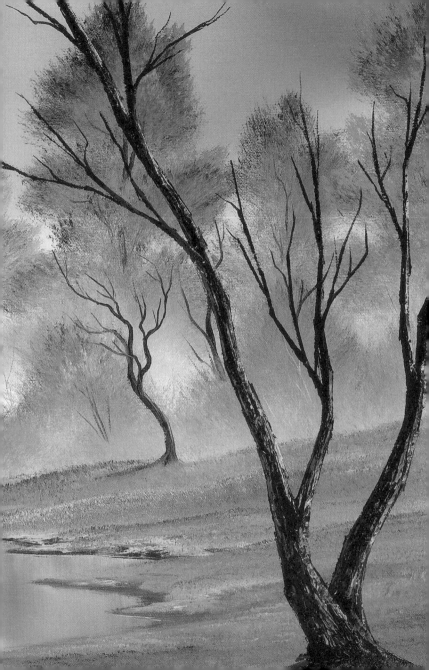

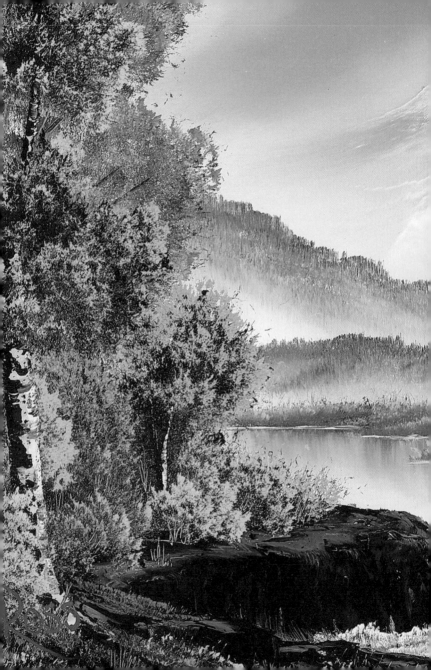

Bravery Test N° 54

*"Just let go and
fall like a little waterfall."*

LET GO OF PERFECTIONISM. MANY OF US
tend to focus on the details to the point that
we can't see the larger picture. Spending
too much time obsessing over insignificant
details can rob your world of joy. Learn to let
go of the need for control and perfection,
and simply let it be. Any time you start to
get anxious and try to control every little
thing, imagine yourself flowing like water,
not knowing where you're going, just that
you'll eventually get where you need to be.
Those minor details will get worked out in
their own time.

Bravery Test Nº 55

"Everything's not great in life, but we can still find beauty in it."

FIND BEAUTY IN THE DARKNESS. AT TIMES the world feels like a dark place, but there is good in it. Even among all the dark clouds in some of his paintings, Bob would make sure there was a ray of light somewhere. Create art focusing on the good in life, capturing some of the beauty you see. Whether it's in a sketchbook you keep in your bag or a poem typed into your phone on the subway ride home from work, highlight the beauty both in your life and in the world around you in art you create while you're in the moment.

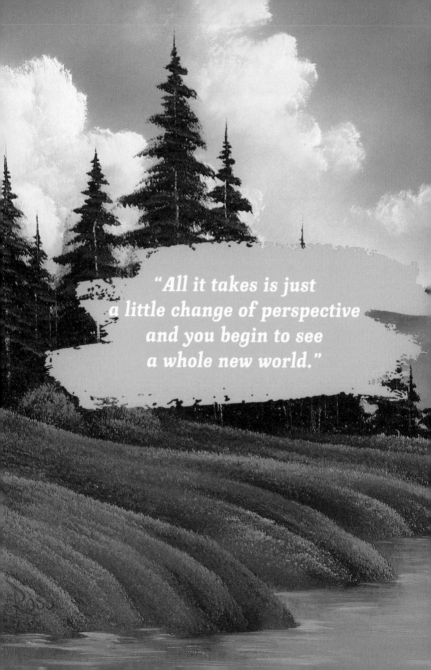

"*All it takes is just a little change of perspective and you begin to see a whole new world.*"

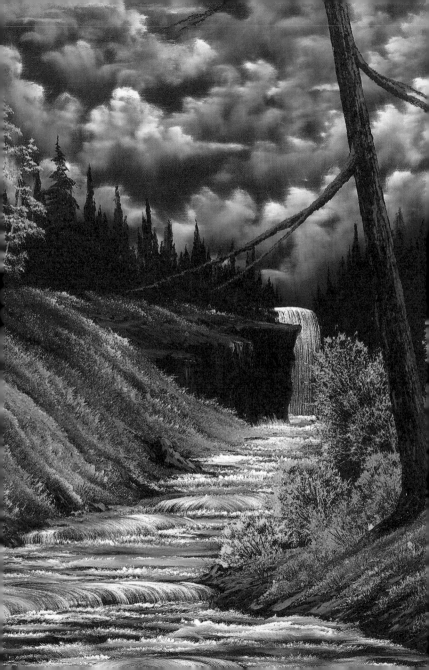